THIS JOURNAL BELONGS TO:

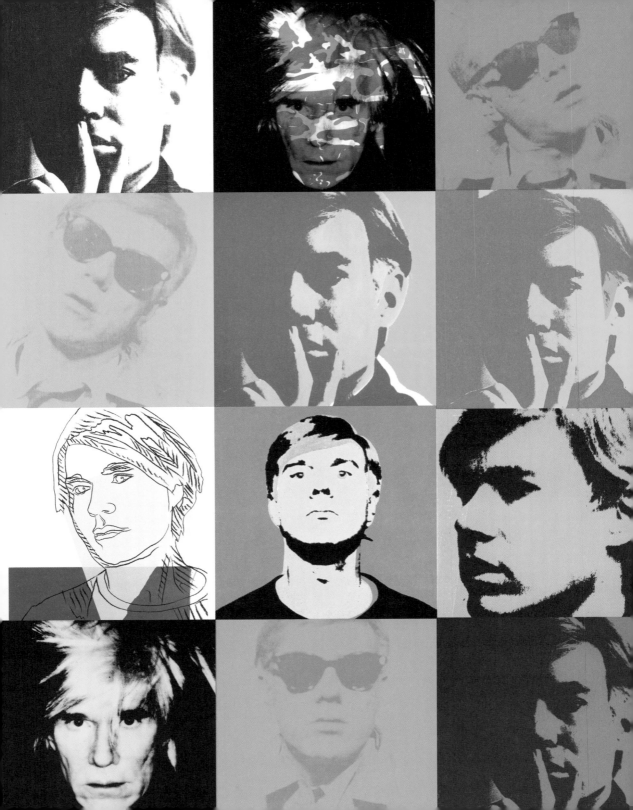

FACE IT

From Elizabeth Taylor and Marilyn Monroe to Chairman Mao to Queen Elizabeth II, who doesn't recognize Andy Warhol's pop portraits of celebrities? Yet throughout his career, Warhol most often worked with his own image—from early photo booth style photos to the series of spiked hair self-portraits he was working on just before his death in 1987. **PICK A STYLE AND "WARHOLIZE" YOUR OWN IMAGE!**

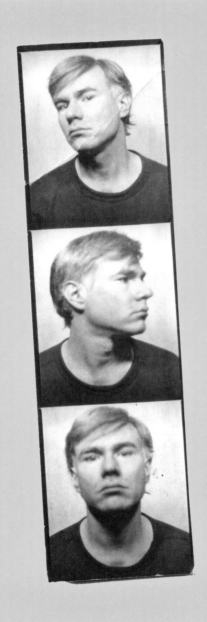

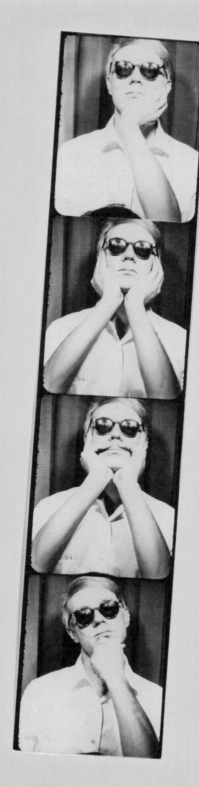

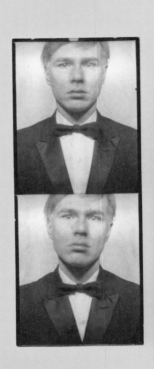

"IT TAKES A LOT OF WORK TO FIGURE OUT HOW TO LOOK SO GOOD."

Andy Warhol

THE IDEA OF WAITING FOR SOMETHING MAKES IT MORE EXCITING

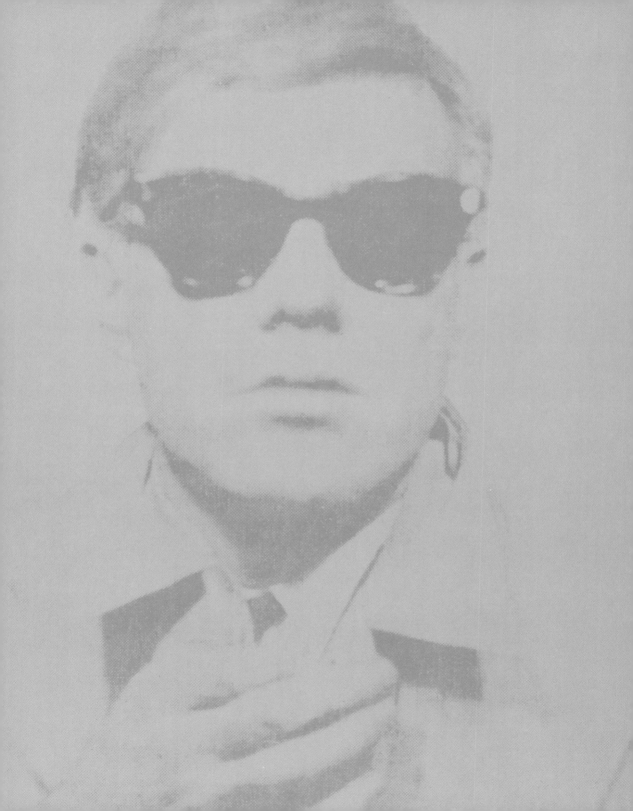

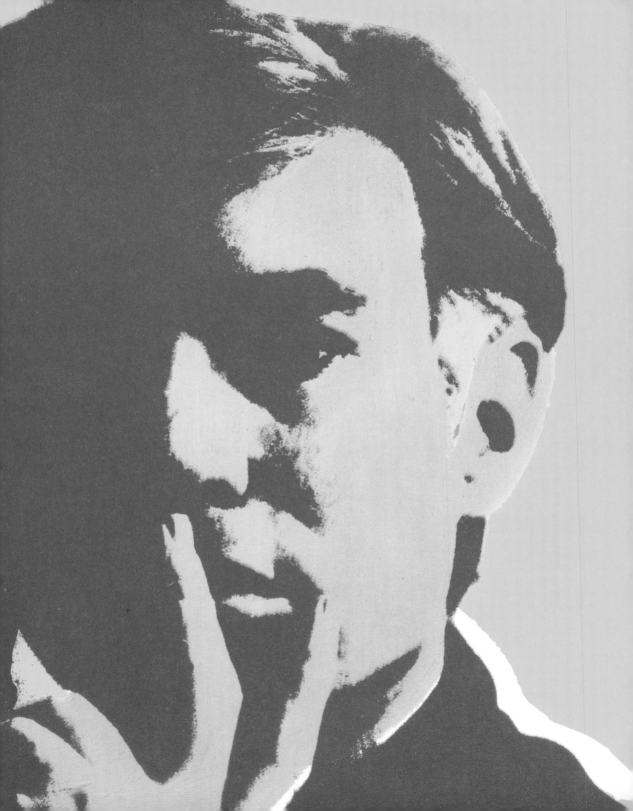

15 MINUTES OF FAME

Back in 1968, Andy Warhol famously quipped that "In the future, everybody will be world-famous for 15 minutes." He later liked to play with this quotation, for example, "In the future, fifteen people will be famous," or "In fifteen minutes, everybody will be famous." In today's interconnected world, it's been said that "On the Web, everyone will be famous to fifteen people." **DESCRIBE YOUR 15 MINUTES OF FAME...OR LIST THE 15 PEOPLE TO WHOM YOU ARE FAMOUS!**

I ONLY HAVE EYES FOR YOU

Andy Warhol may have said that "people should fall in love with their eyes closed," but the open eyes he illustrated are varied and exciting, whether human or feline. **DRAW YOUR EYES, AND MAYBE YOUR FRIEND'S, TOO!**

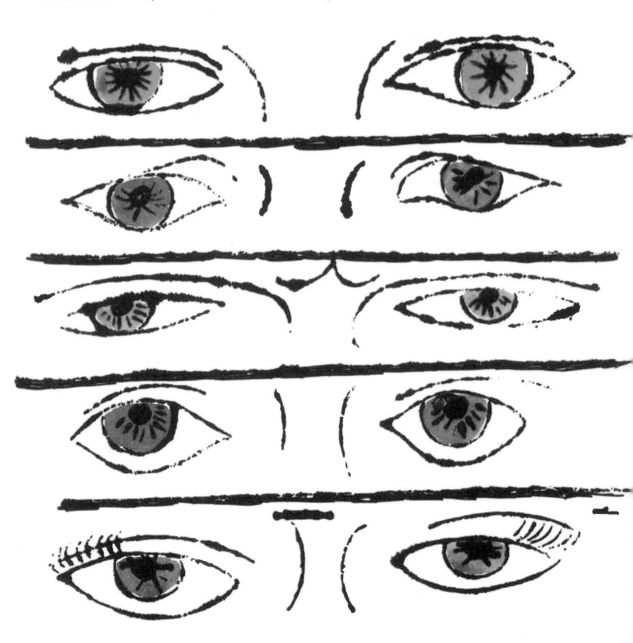

Campbell's SOUP

Follow the instructions below to reproduce the first of Andy Warhol's iconic Campbell's Soup Can paintings, *Tomato*. Warhol painted 32 of the classic red and white cans, and exhibited the series at the Ferus Gallery in Los Angeles in 1962. He referred to a product list supplied by the Campbell Soup Company and checked off each type of soup as it was completed. Tomato was the first, but if you want, go wild and draw Scotch Broth!

INSTRUCTIONS:

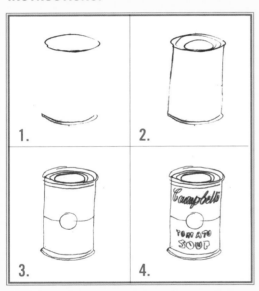

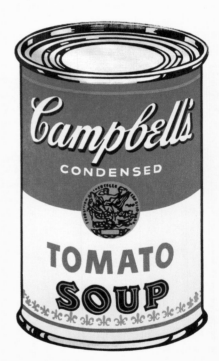

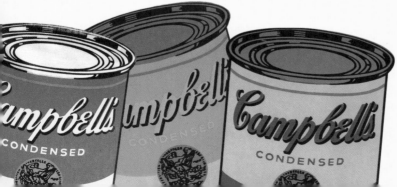

Above:
Andy Warhol (1928-1987)
Campbell's Soup Can (Tomato), 1962

Left:
A 1965 Campbell's Soup Cans series uses imaginatively colored cans and spray-painted backgrounds.

1.

2.

3.

4.

I NEVER MET AN ANIMAL I DIDN'T LIKE. *Andy Warhol*

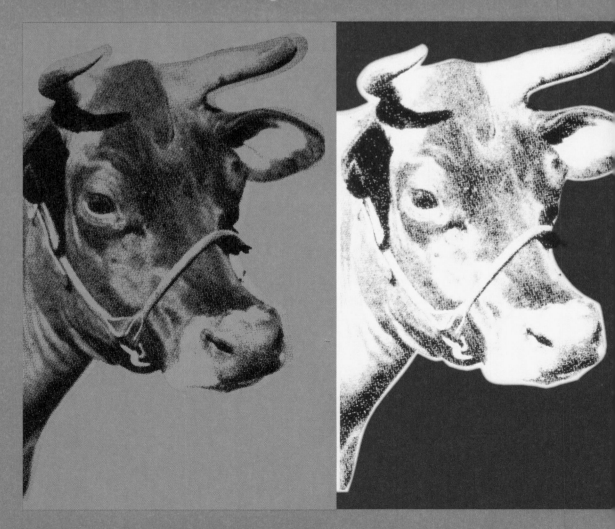

HOW NOW RED COW

Andy Warhol's silk screened cow wallpaper was installed in at the Leo Castelli Gallery, New York, in April, 1966. Warhol took the repeated bovine image from a book on animal husbandry, where it was titled "A Good Jersey Head." In another room, he installed silver helium-filled pillows as "Silver Clouds." **DRAW YOUR OWN FAVORITE COW.**

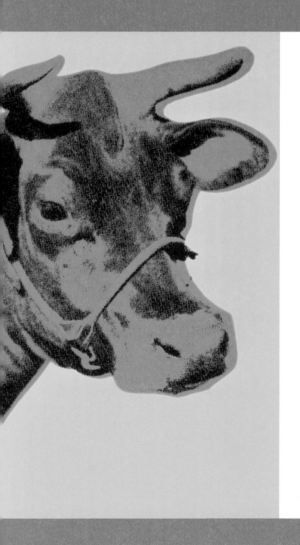

WARHOL PHILOSOPHY

From outrageous to fey, Andy Warhol always had something provocative to say. His candor naturally developed into a philosophy of his own embodying topics like love, beauty, money, class, and style. How about you? **INSCRIBE A PENCIL WITH YOUR OWN THOUGHTS OR RESPOND TO WARHOL'S!**

Andy Warhol ART IS WHAT YOU CAN GET AWAY WITH.

Andy Warhol EVERYBODY MUST HAVE A FANTASY.

IF YOU WANT TO KNOW ALL ABOUT AND
WARHOL, JUST LOOK AT THE SURFACE: O
MY PAINTINGS AND FILMS AND ME, AN
THERE I AM. **THE WORLD FASCINATES M**
I NEVER READ, I JUST LOOK AT PICTURE
ART IS WHAT YOU CAN GET AWAY WITH
ISN'T LIFE A SERIES OF IMAGES THA
CHANGE AS THEY REPEAT THEMSELVES

I AM A DEEPLY SUPERFICIAL PERSON

I NEVER FALL APART BECAUSE I NEVE
FALL TOGETHER. SHE REALLY HAS CLAS
BECAUSE SHE'LL GO ANYWHERE. I THIN
EVERYBODY SHOULD LIKE EVERYBODY
WASTING MONEY PUTS YOU IN A REA
PARTY MOOD. EVERYONE IS RICH, EVERY
ONE IS INTERESTING. WHEN YOU THIN
ABOUT IT, DEPARTMENT STORES AR
KIND OF LIKE MUSEUMS. **-ANDY WARHO**

DO YOU SHARE ANY PHILOSOPHIES WITH WARHOL?

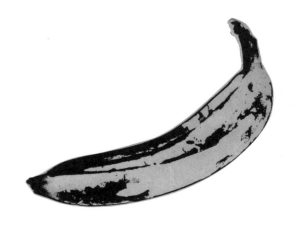

THE DOLLAR SIGN

Andy Warhol got his start as a commercial artist, and he loved money unapologetically. His brash dollar sign paintings of the 1980s confirmed that he saw art as a commodity. Not all money is green. **HAVE FUN CREATING YOUR OWN COLORFUL CURRENCY.**

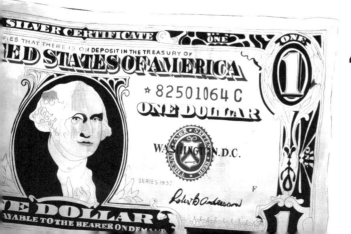

"MAKING MONEY IS ART AND WORKING IS ART AND GOOD BUSINESS IS THE BEST ART."

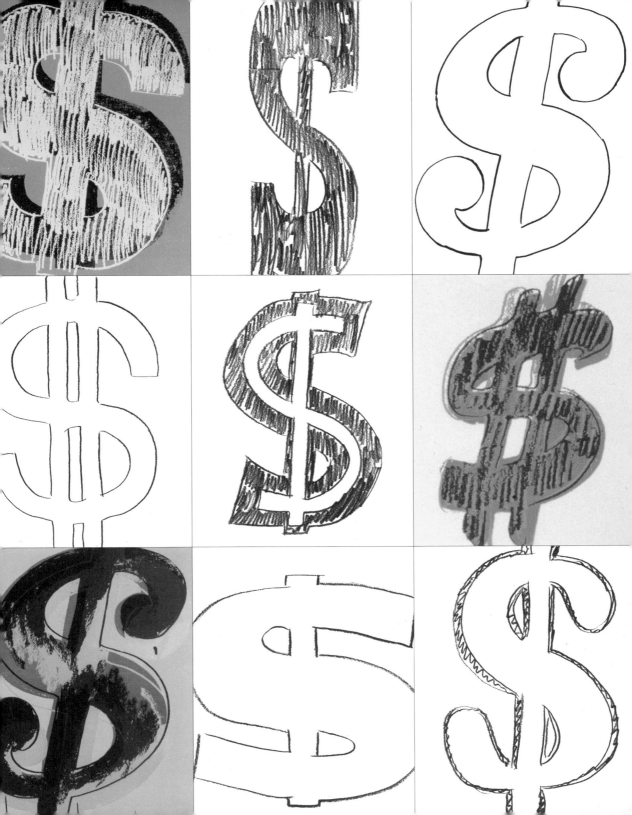

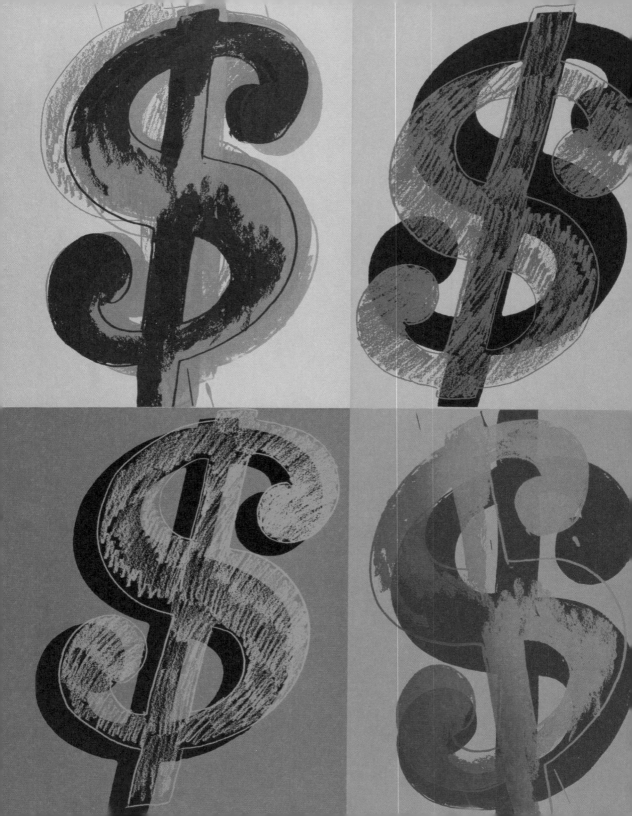

BEING GOOD IN
BUSINESS IS
THE MOST FASCINATING
KIND OF ART

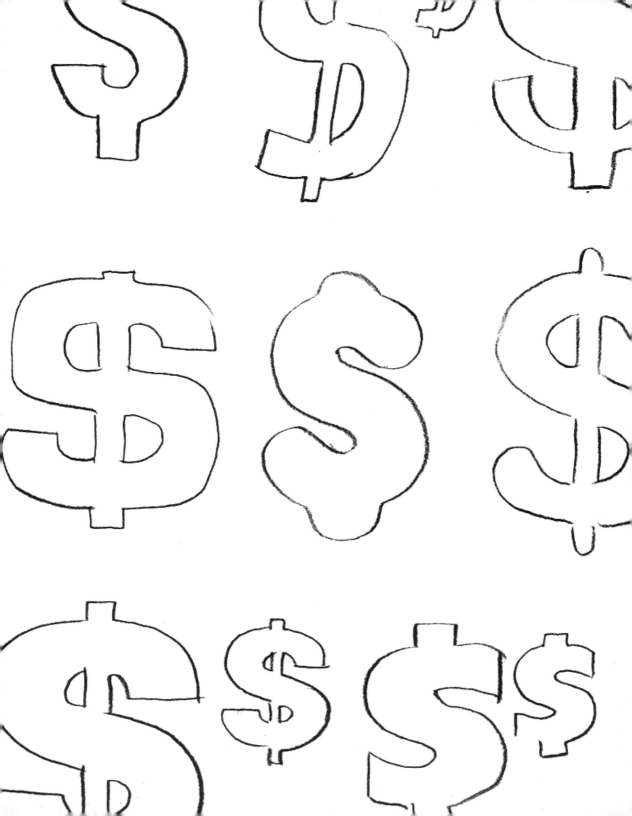

SHOES, SHOES, SHOES...

Early in his fashion magazine advertising career, Andy Warhol became known for his illustrations of shoes. Over the course of his career he continued to create drawings and paintings of high heel shoes—from spikes to boots to mules to the sparkle of his 1980 Diamond Dust—that are iconic. Although it was never on his resume, Warhol decided that "being a shoe salesman is a really sexy job." **DESIGN A SHOE OF YOUR OWN—SEXY OR NOT—USING WARHOL'S SKETCH OUTLINES.**

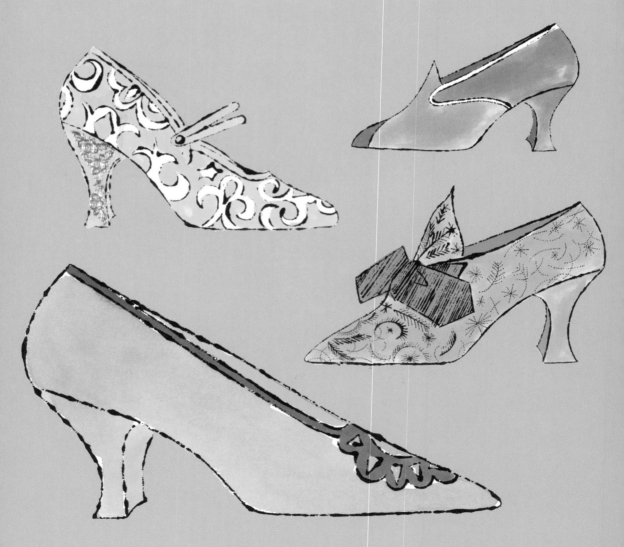

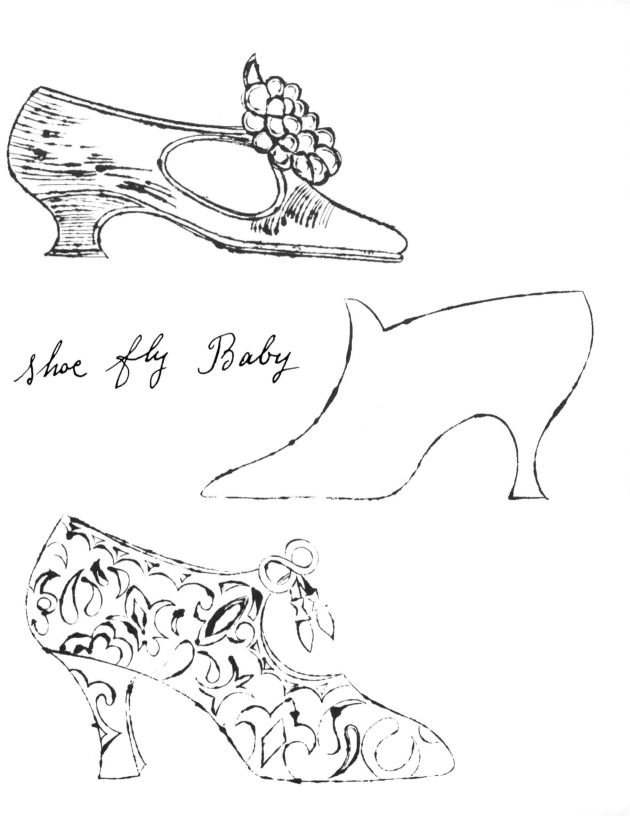

shoe fly Baby

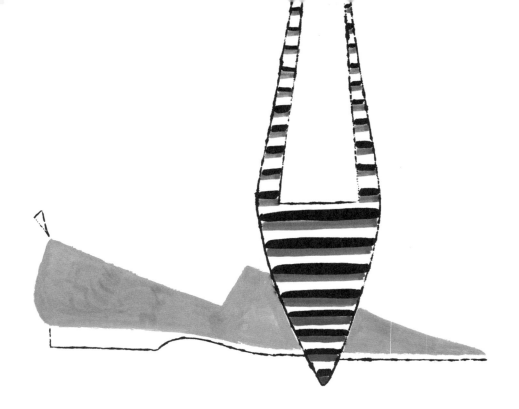

shoe bright, shoe light, first shoe ive seen
 tonight

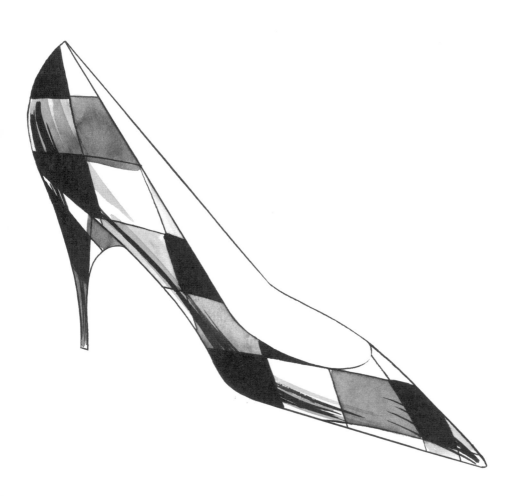

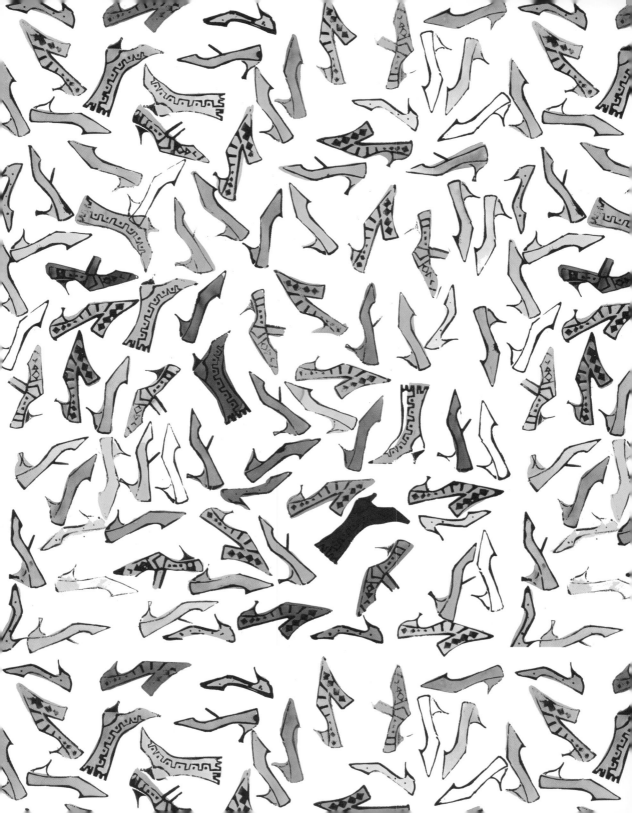

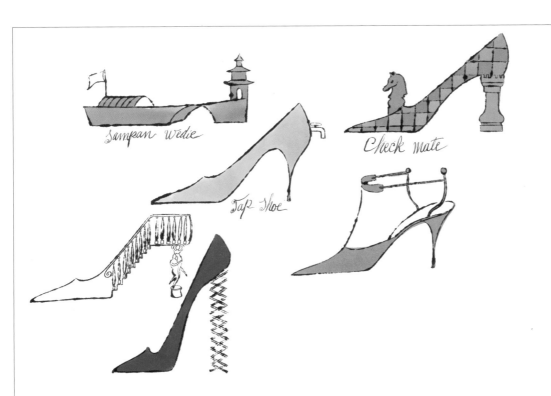

Sampan Wedie

Check Mate

Tap Shoe

Shoe of the evening, beautiful shoe.

See a shoe and Pick it up and all day
long you'll have Good Luck

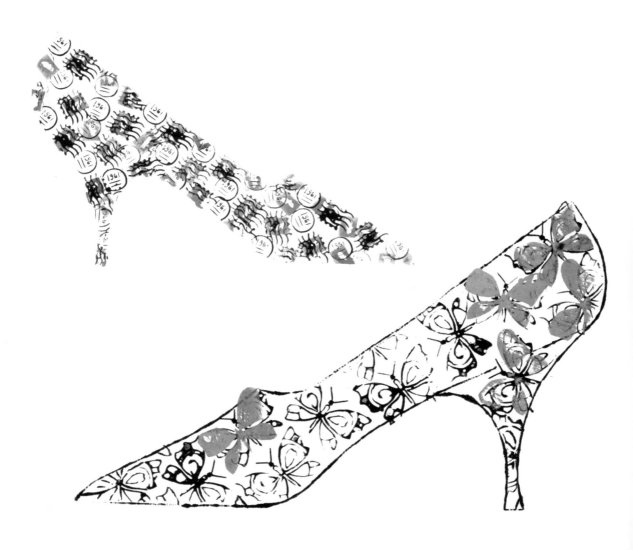

WARHOL FASHIONISTA

In the 1950s, Andy Warhol worked as a commercial illustrator in New York City, drawing everything from shoe advertisements to fashion plates in his own characteristic style. Famously, he once said: "Fashion wasn't what you wore someplace anymore; it was the whole reason for going." **WHAT DOES YOUR STYLE REFLECT? SHOW IT OFF IN THE MIRROR TO THE RIGHT.**

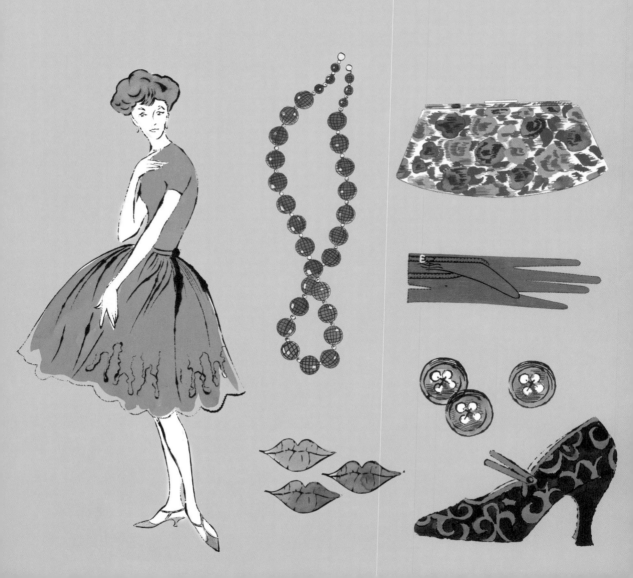

FASHIONABLE FACES

Andy Warhol saw a face as the projection of an artificial identity onto a mask to create. Anyone could be beautiful. **CREATE SOME STYLISH OR OUTRAGEOUS PERSONAE OF YOUR OWN. DON'T FORGET THE ACCESSORIES!**

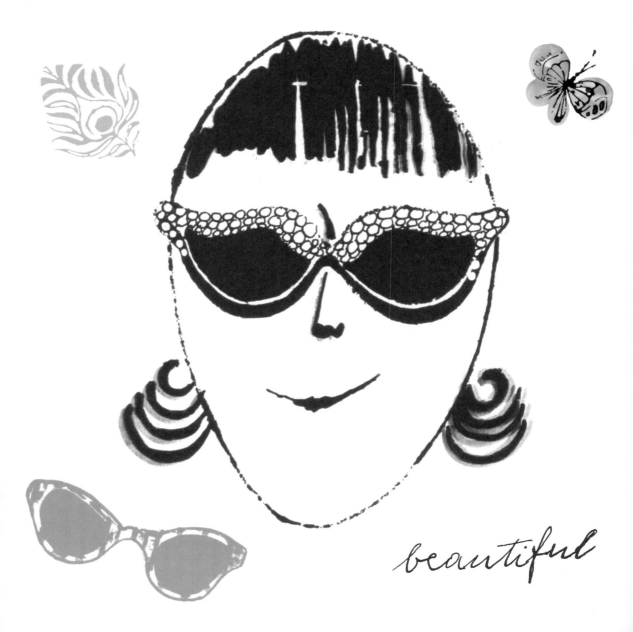

beautiful

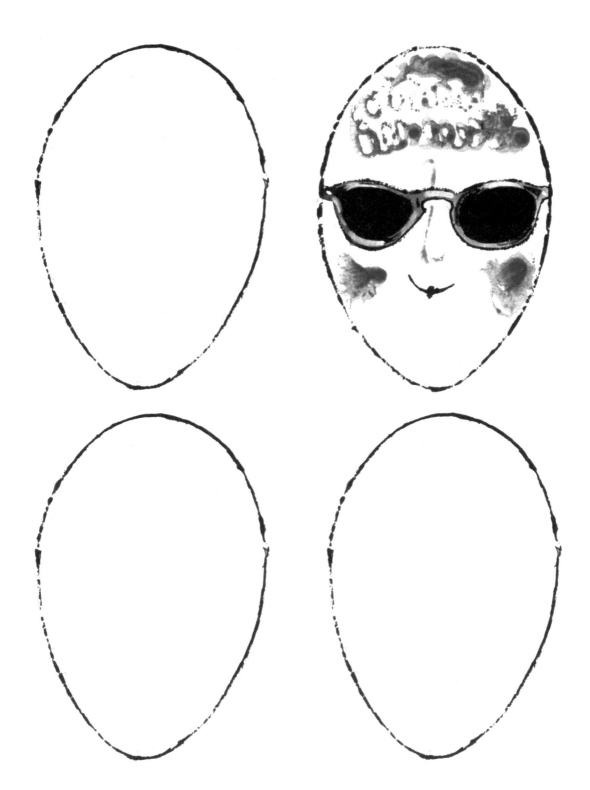

WARHOL HAD A UNIQUE STYLE. WHAT'S YOURS?

"JUST DRESS TO MINGLE."

PARTY HAT COLLECTION

Andy Warhol's ink and watercolor drawings of marvelous millinery was published in the holiday issue of McCall's Magazine in 1964. From a pirate hat to a bonnet for Scarlett O'Hara, hats were identified with popular characters. **WHO WOULD YOU BE? CREATE YOUR OWN HEADDRESS!**

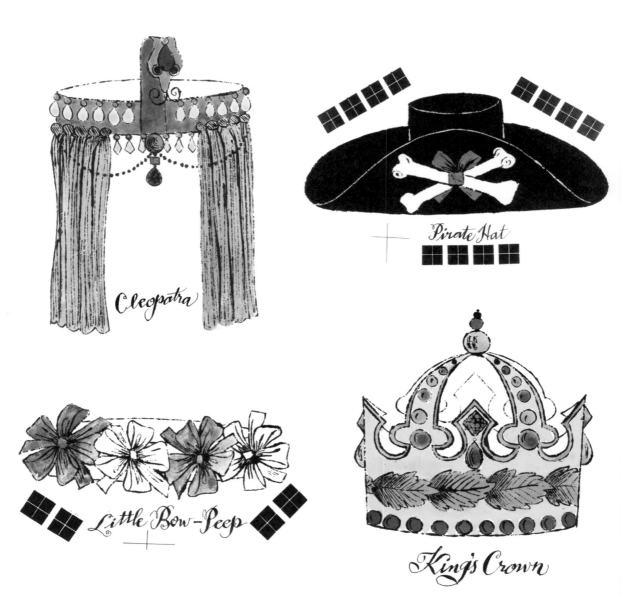

Cleopatra

Pirate Hat

Little Bow-Peep

King's Crown

Scarlet O'Hara

Robin Hood

DO IT YOURSELF

Ironic or artistic? Based on popular paint-by-number kits of the 1950s, Warhol created a whole series of Do It Yourself paintings, including this one from 1962. **CAN YOU STAY WITHIN THE LINES?**

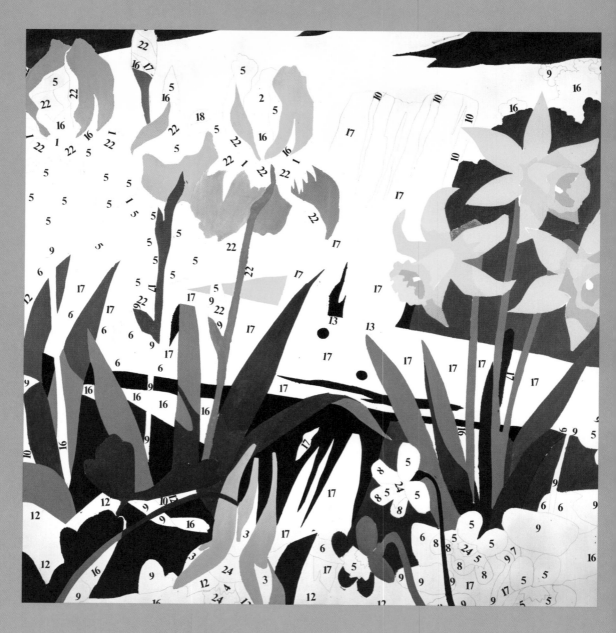

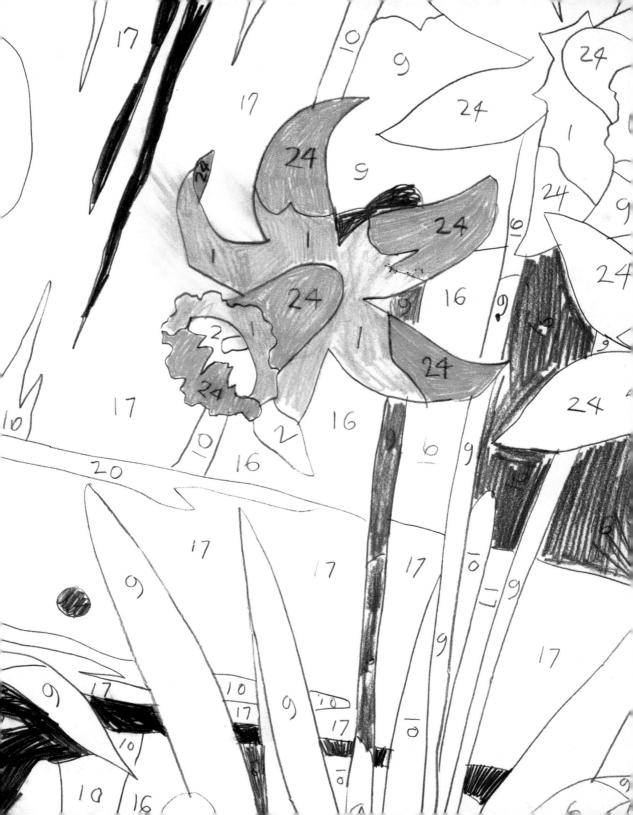

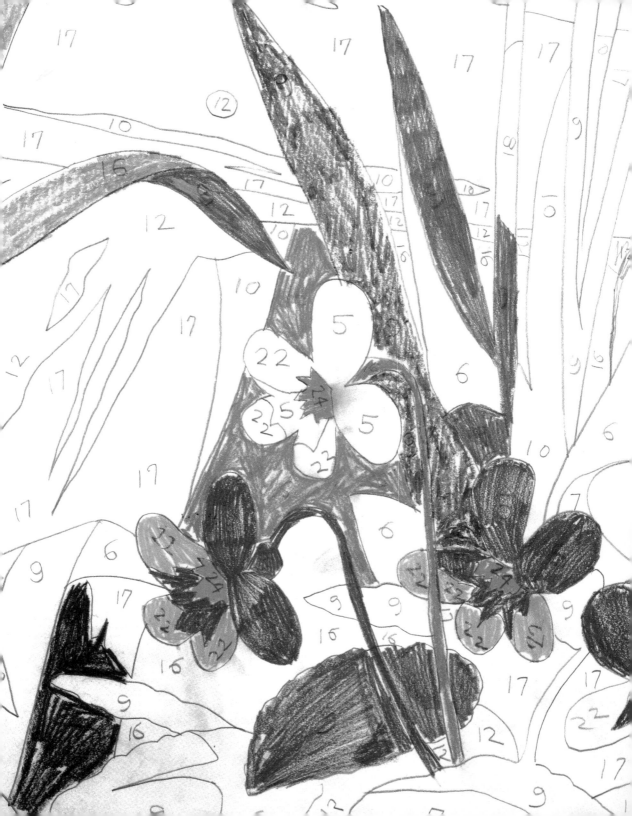

STOP TO SMELL THE FLOWERS

Colorful and cheery, Andy Warhol's flower artwork could brighten a room just like the real thing! Using a variety of mediums and brilliant colors, he brought the best of nature inside. **PLANT YOUR OWN GARDEN IN THE SPACE BELOW.**

BE INSPIRED BY WARHOL'S COLOR PALETTE AND CREATE ONE OF YOUR OWN!

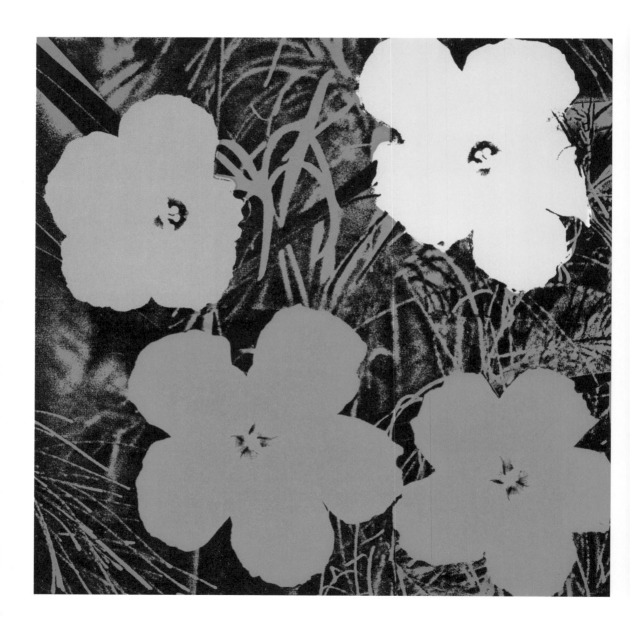

Andy Warhol

ART GALLERY

Over the course of his career, Andy Warhol transformed contemporary art. Employing mass-production techniques to create works, Warhol challenged preconceived notions about the nature of art and erased traditional distinctions between fine art and popular culture. **WHAT POP CULTURE ART CAN YOU CREATE?**

"I NEVER READ, I JUST LOOK AT PICTURES."

Andy Warhol

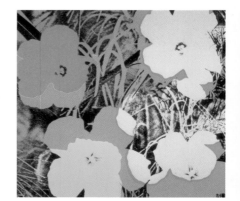

WHAT DO WARHOL'S WORDS AND PICTURES CONJURE IN YOUR MIND?

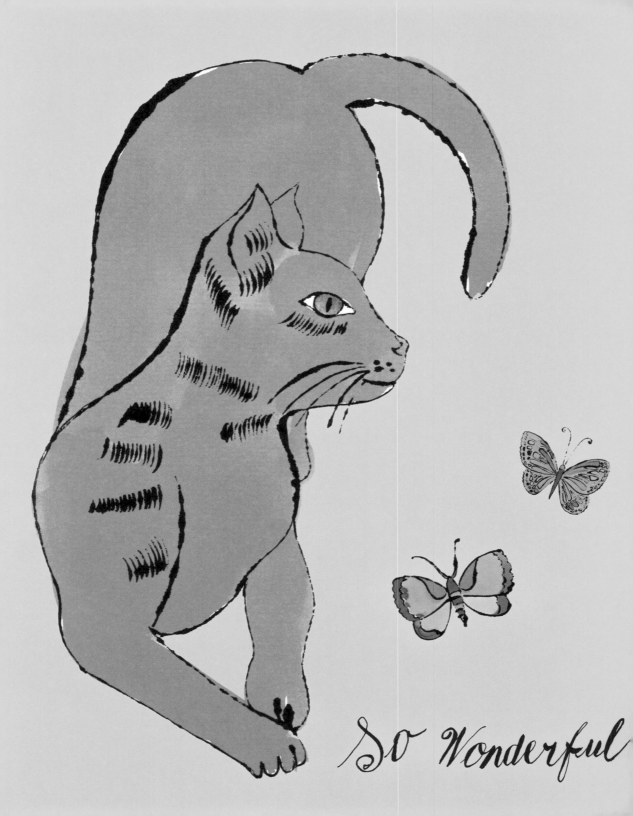

So Wonderful

CATS, CATS, CATS...

Cats of all kinds were one of Andy Warhol's most famous subjects—from fatigued felines to curious kitties. What do dozing kittens, regal tomcats, and a cat named Sam have in common? They were all feline models for Andy Warhol! **USE WARHOL'S OUTLINES TO DRAW YOUR OWN PERSONALITY-FILLED FURRY FRIENDS.**

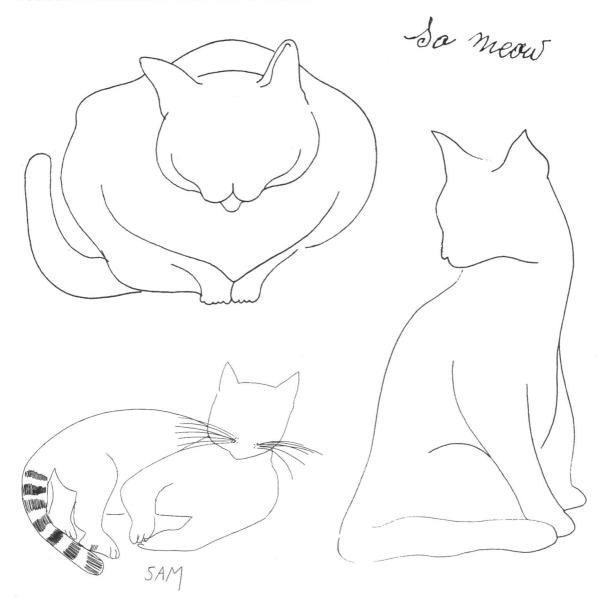

So meow

SAM

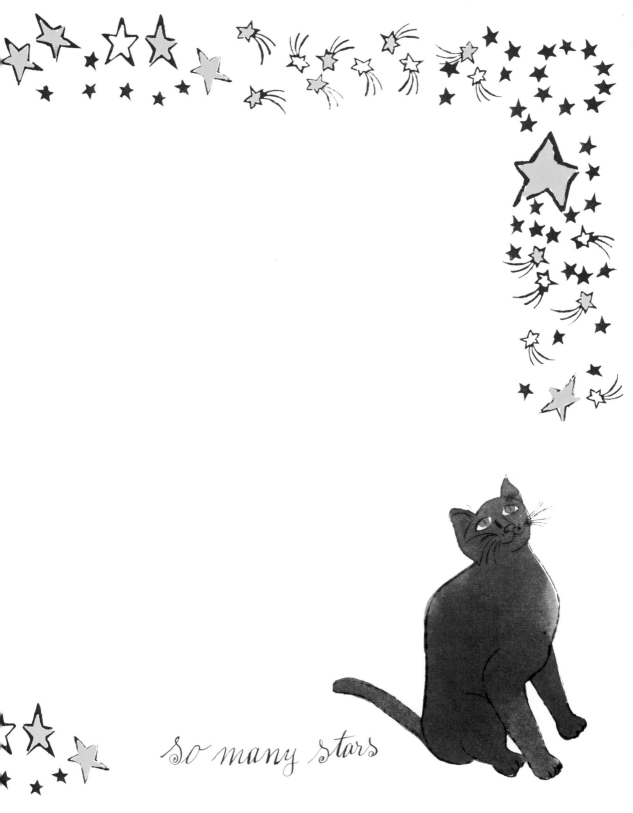

so many stars

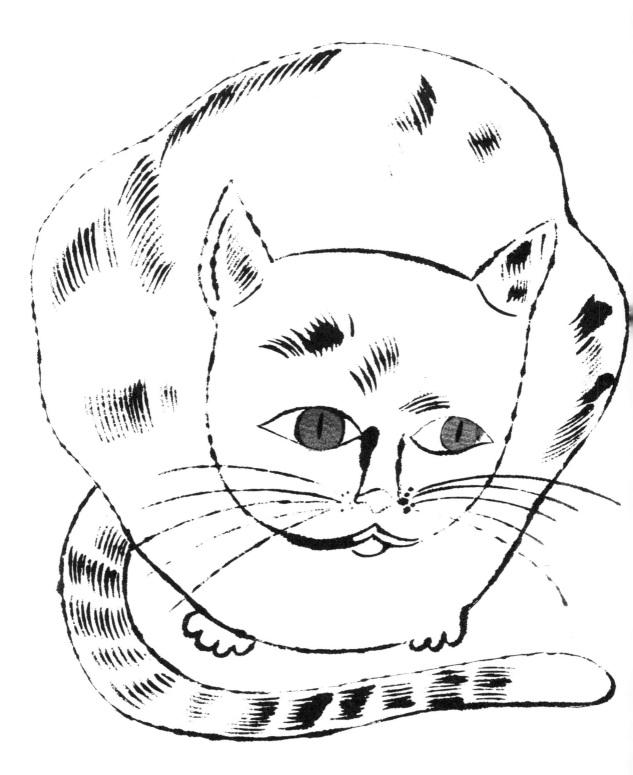

So there you are

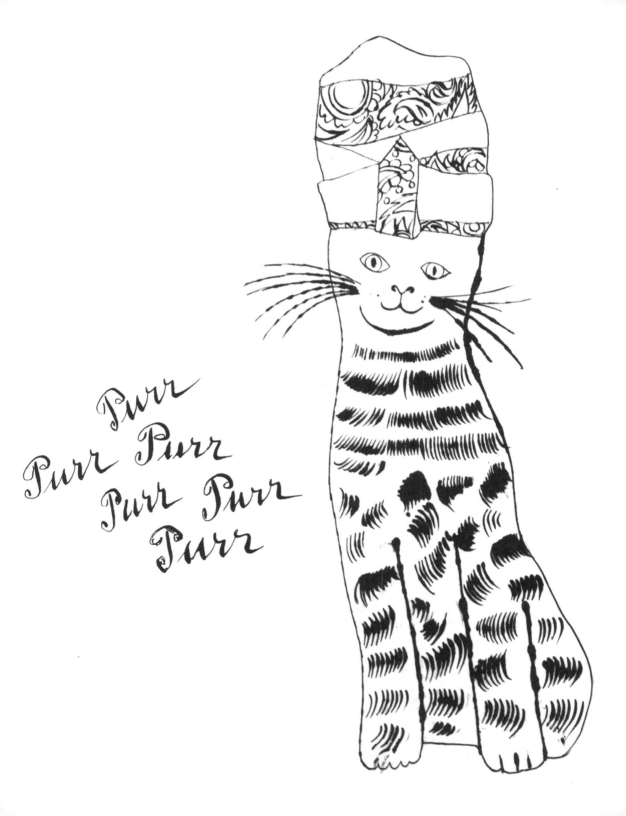

Purr
Purr Purr
Purr Purr
Purr

So meow

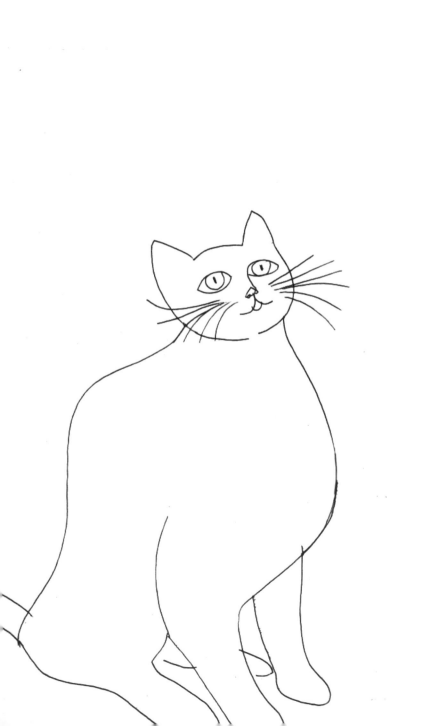

"I LOVE ANIMALS. I ONCE HAD TWENTY-SIX CATS."

PLAYING AROUND

With his signature bright colors and larger-than-life compositions, Warhol created a series of "Toy Paintings" designed to delight children. With subjects pulled from charming toy packaging, the artworks capture the nostalgia and joy of childhood. **DRAW SOME OF YOUR FAVORITE TOYS.**

SO...WHAT?

Two letters packing a punch: that's "so"! Andy Warhol loved this adverb, putting it in front of descriptive words and pairing the phrase with a drawing. The cat is so meow! The snail is so slow! **SO...WHAT COMES TO MIND FOR THESE OTHER PAIRS?**

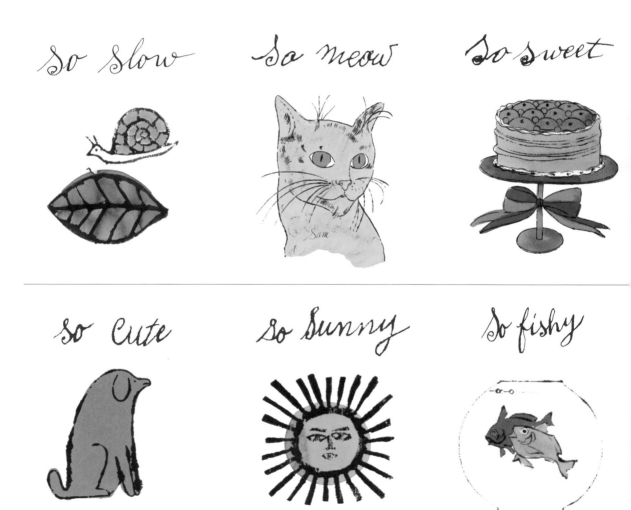

So slow

So meow

So sweet

So cute

So sunny

So fishy

So slow So meow So Happy

So Cute So Sunny So fishy

So many stars So Wonderful So sweet

you are so little

and you are so *big*

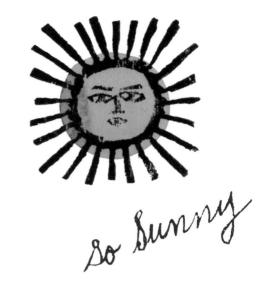

So Sunny

so slow

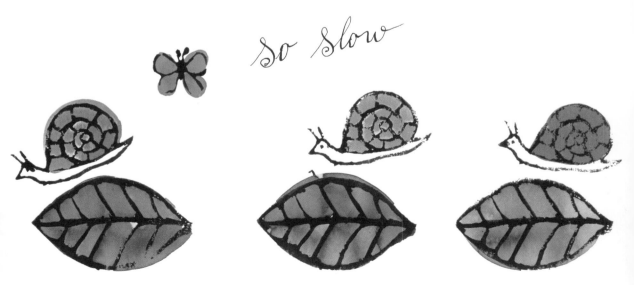

READY FOR A TREAT?

Desserts never looked so delectable! Andy Warhol liked to turn the ordinary into the extraordinary, and his delightful drawings of sweet treats are no exception. **INDULGE YOUR SWEET TOOTH AND CUSTOMIZE YOUR CONE!**

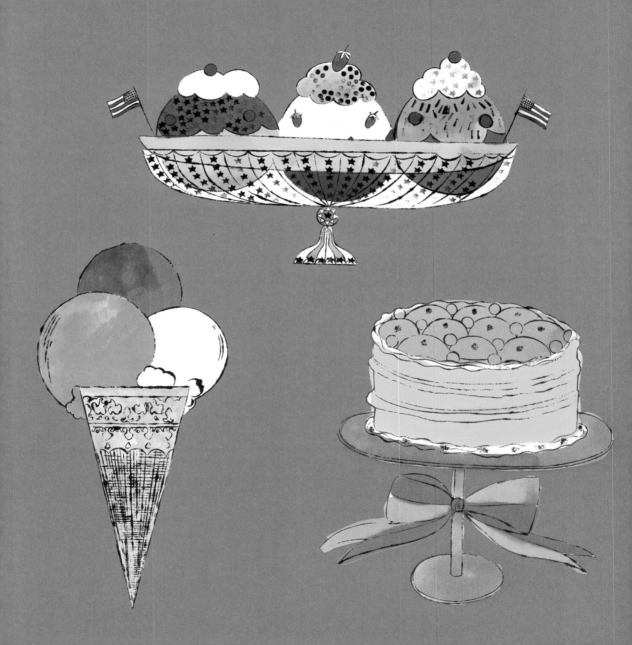

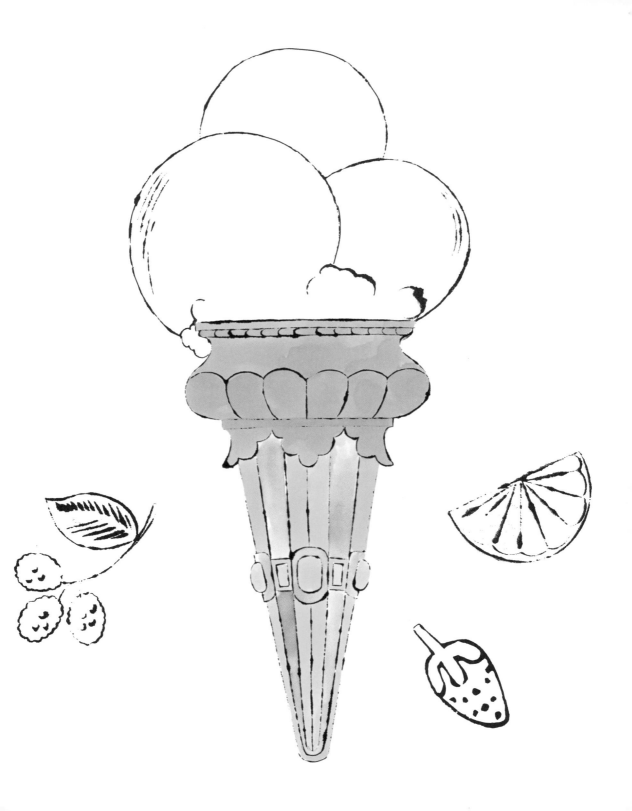

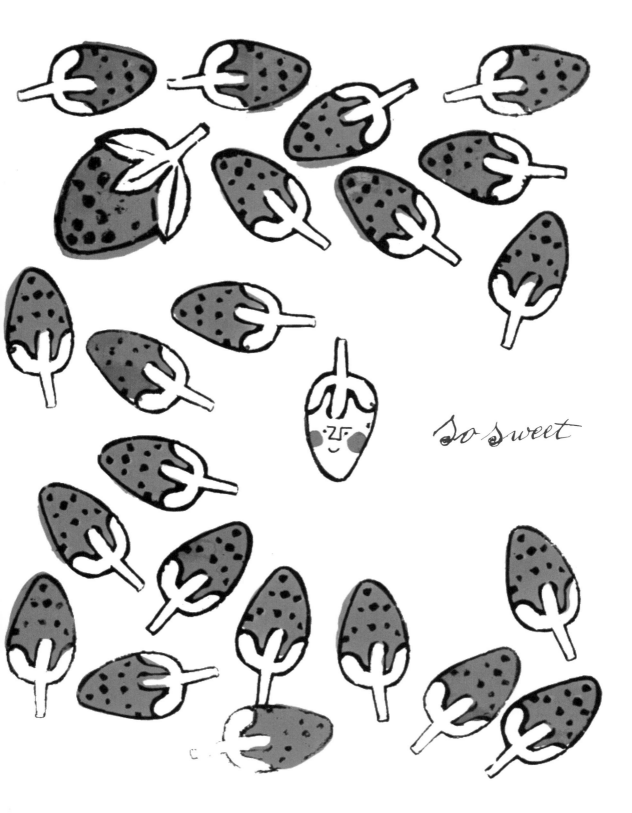

so sweet

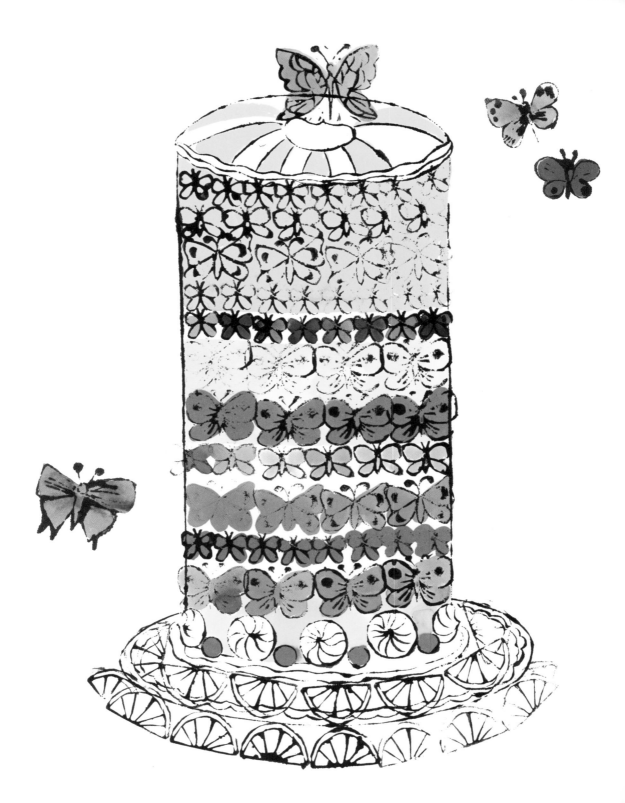

So sweet

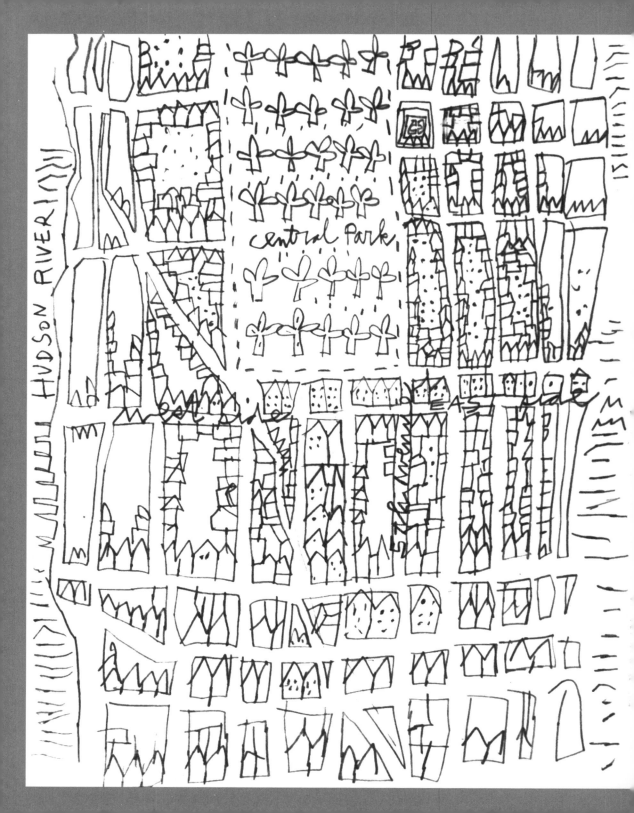

SHOW ME TO YOUR STUDIO

Like so many artists, Andy Warhol found New York City to be very inspirational. In his drawings of maps and street signs, he captured the vibrant, ever-moving life of the city. Warhol's NYC studio, The Factory, became a local legend and creative landmark; it had three different locations in 22 years. The original location was in midtown Manhattan (231 East 47th Street), while the last two locations were near Union Square (33 Union Square West and 860 Broadway). **WHAT ARE YOUR FAVORITE ART SPOTS?**

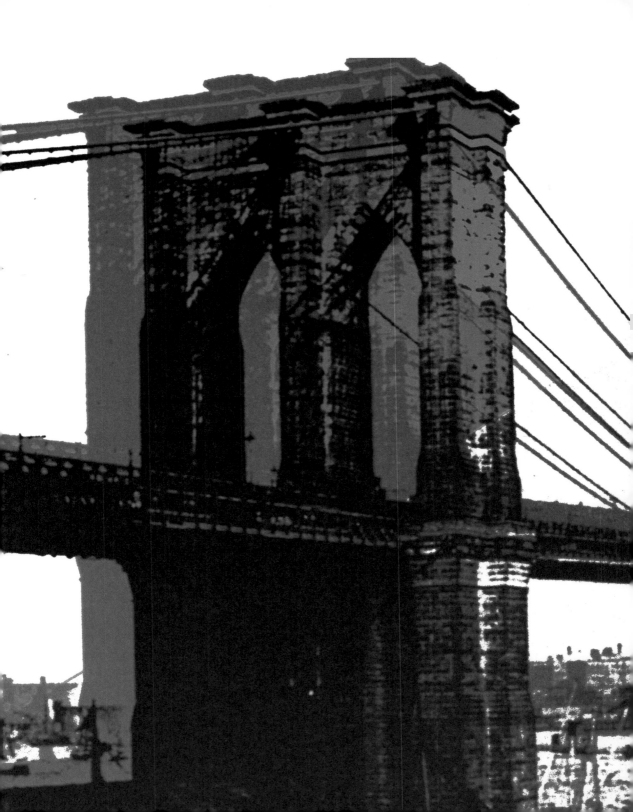

WHERE IN NEW YORK DO YOU FIND INSPIRATION?

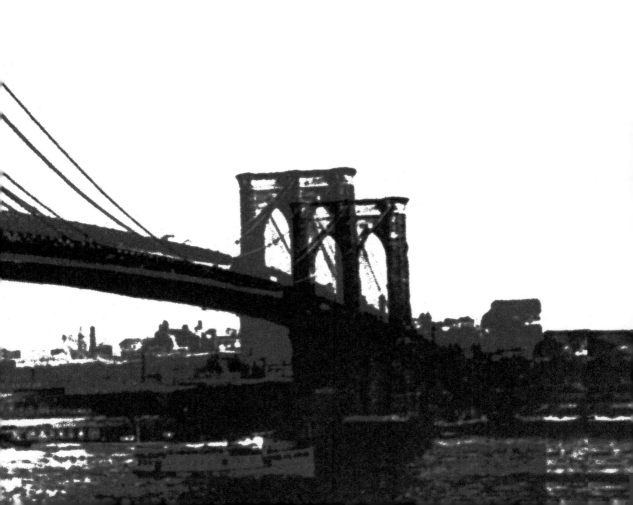

BUTTERFLIES, BIRDS, BEES

Andy Warhol brought the beauties of nature into his studio by incorporating birds, bugs, and plants into this whimsical wrapping paper. Using his trademark "blotting technique," he laid a blank sheet of paper over wet ink to transfer a charmingly imperfect image. GO OUTSIDE, LOOK AROUND, AND MAKE A PATTERN OF YOUR OWN—BLOT OR NOT!

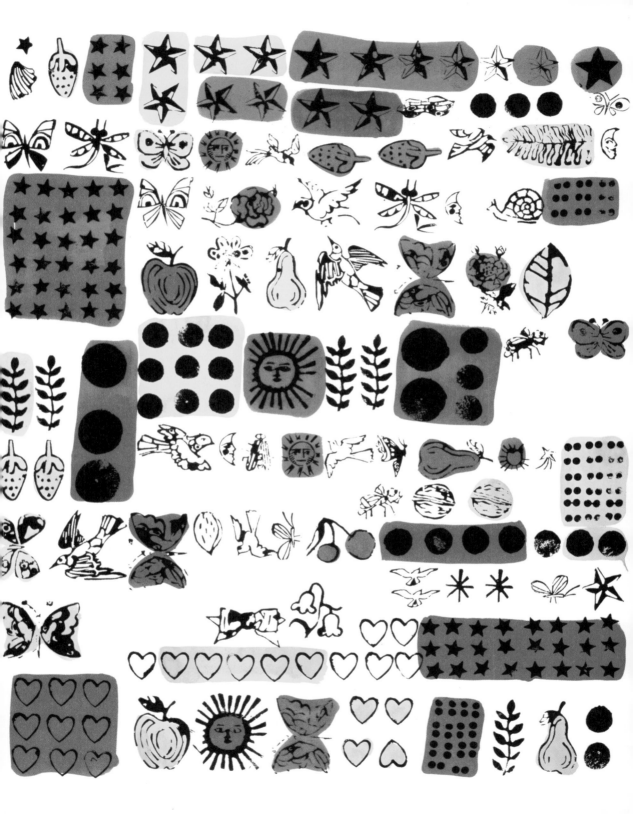

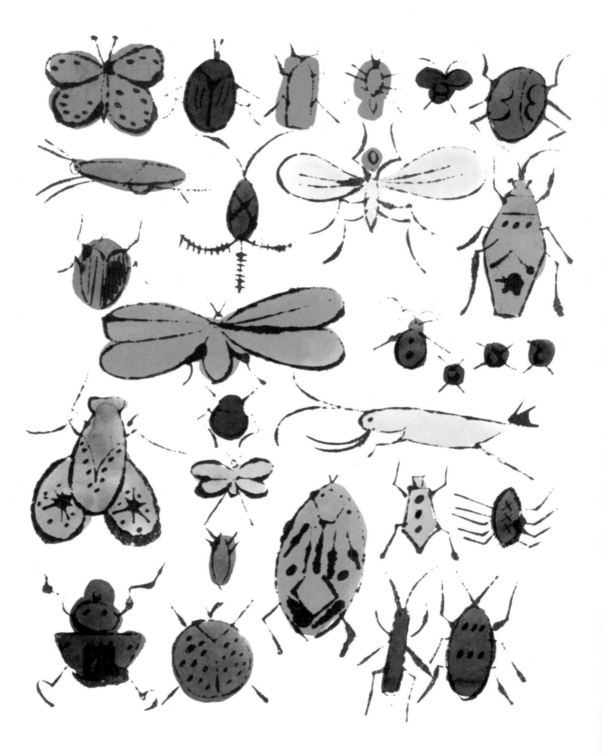

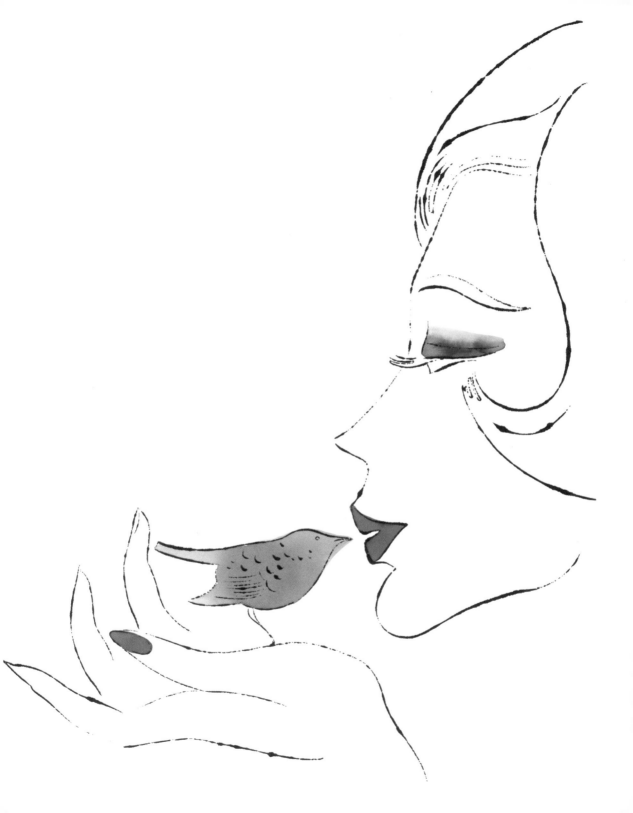

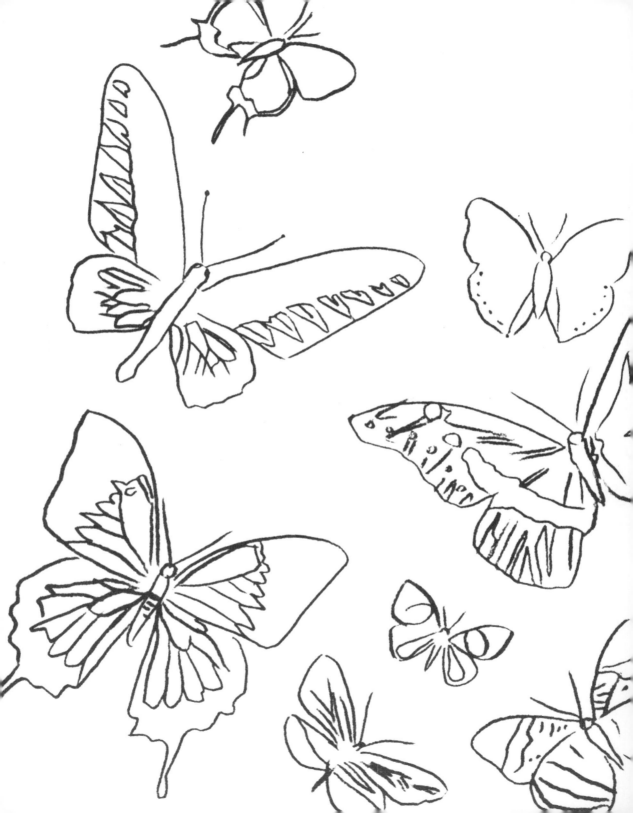

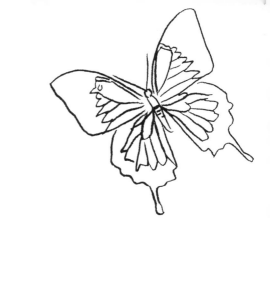

HERE is andy at the age of two
Looking wistfully at you
He has wing like a butterfly
And if you ask the reason why
He will ~~say~~: Im a butterfly you
all
wont you come and fly with me.

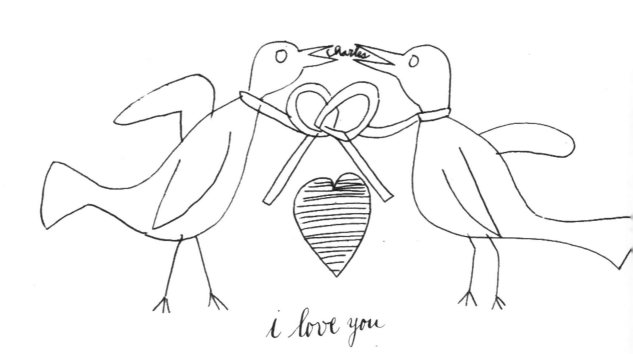

i love you

TRY EMULATING THE BLOTTED LINE
TECHNIQUE IN THE FRAME...

WRITE LIKE WARHOL

Long before the age of blogs and Facebook, Warhol kept meticulous records of his thoughts on paper and audio tapes, giving us a glimpse into both his public persona and private thoughts. **USE THESE PAGES TO WRITE YOUR OWN JOURNAL ENTRIES ABOUT EVERYDAY THINGS THAT INSPIRE YOU THE MOST.**